The Practical Guide to

DRAWING
ANATOMY

The Practical Guide to

DRAWING
ANATOMY

BARRINGTON BARBER

ARCTURUS

Arcturus

This edition published in 2011 by Arcturus Publishing Limited
26/27 Bickels Yard, 151–153 Bermondsey Street,
London SE1 3HA

Copyright © 2011 Arcturus Publishing Limited/Barrington Barber

ISBN: 978-1-84837-829-2
AD001644EN

Printed in China

CONTENTS

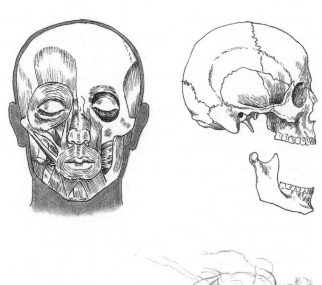

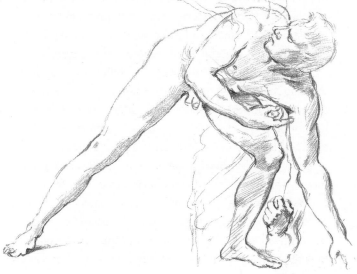

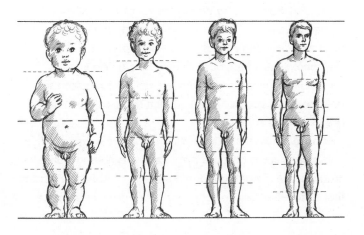

INTRODUCTION

Anatomy books are essential for figure artists, but many are published for medical purposes and tend to give too much information. For example, while the inner organs of the body may be interesting to know about, they are not relevant for drawing.

What is important for the artist or art student to learn is the structure of the human form, based on the skeleton and musculature. There have been a number of good books on this subject. Some are a little out of date, not in the information that they give but often in the way it has been presented. Well-produced contemporary books are mainly illustrated by photographs.

My task here has been to produce an overview of the human anatomy that has all the information necessary for an artist, using drawings and diagrams presented in an easy-to-follow format; and I also wanted to put into it tips that I have found useful in my own drawing practices.

In the first part of this book I deal with the full figure, showing the skeleton, then the muscles that lie on top of the bone structure, and finally the surface form of the human body. Following this, I examine each major part of the body in more detail, concentrating in particular on musculature. Each area of detailed analysis will sometimes repeat what has been shown in previous pages: this is necessary because some muscles overlie others, which to a certain extent changes their shape on the surface. So don't be surprised to see the same names cropping up from time to time, and it does make them easier to remember. Finally, I look at the body in movement.

In the technical introduction opposite, you will find an explanation of some descriptive terms that are used in medical circles. This is well worth reading, because understanding anatomical terms will help you to follow the annotations in the book. It may take a little time to remember all the names you need, but after regular use of these terms you will recall enough to describe what you are looking at.

I have omitted any description of the brain, heart, lungs and other viscera because these items are housed within the cranium, the ribcage and the pelvis, and it is the bony parts that dictate the surface shape for figure-drawing purposes.

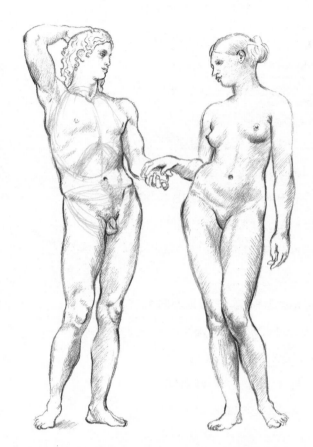

Of course, not all human bodies are perfectly formed and proportions do differ from person to person. Throughout the book I have used well-proportioned, fairly athletic figures. This means that you become acquainted with the shapes of the muscles at their best, although you will probably draw many people who do not have well-toned bodies like these.

Throughout history, artists have looked at the human form and shown its beauty, force and distortions. I have used the best possible references to draw these pictures, including my own life studies, but have not drawn from dissected corpses, as artists such as Michelangelo and Leonardo da Vinci did; in fact artists have contributed a lot to the study of anatomy for medical as well as artistic purposes. In learning about the human body, you will be following a long and proud tradition that has engaged the interest of artists for centuries.

TECHNICAL INTRODUCTION

BONES

The skeleton is the solid framework of the body, partly supporting and partly protective. The shape of the skeleton can vary widely. It will affect the build of a person and determine whether they have masses of muscle and fat or not.

Bones are living tissue supplied by blood and nerves. They can become weaker and thinner with lack of use and malnutrition, or heavier and stronger when having to support more weight. They are soft and pliable in the embryo, and only become what we would consider hard and bone-like by the twenty-fifth year of life.

Humans have 206 bones, but a few fuse together with age and it is possible to be born with some bones missing or even with extra ones present. We each have a skull, ribcage, pelvis and vertebral column, as well as arm, hand, leg and foot bones. Most bones are symmetrical. The bones of the limbs are cylindrical, thickening towards the ends. The projecting part of a bone is referred to as a process or an eminence.

Highly mobile areas of the body, such as the wrists, consist of numerous small bones. Other bones, like the scapula (shoulder blade), can move in all directions, controlled by the muscles around it.

The bones of the cranium (skull) differ from all others. They grow from separate plates into one fused vault to house the brain. The mandible (jawbone) is the only movable bone in the head.

The long bones of the arms and legs act like levers, while the flat bones of the skull, the cage-like bones of the ribs and the basin shape of the pelvis protect the more vulnerable organs such as the brain, heart, lungs, liver and the abdominal viscera.

MUSCLES

The combination of bones, muscles and tendons allows both strong, broad movements and delicate, precise ones. Muscles perform our actions by contracting or relaxing. There are long muscles on the limbs and broader muscles on the trunk. The more fixed end of the muscle is called the head or origin, and the other end – usually furthest from the spine – is the insertion. The thick muscles are powerful, like the biceps; and the ring-shaped muscles (sphincters) surround the openings of the body, such as the eye, mouth and anus. Certain muscles grow together and have two, three or four heads and insertions. Combined muscles also have parts originating in different places.

The fleshy part of a muscle is called the meat, and the fibrous part the tendon or aponeurosis (see overleaf).

Striated (voluntary) muscles operate under our conscious control. The 640 voluntary muscles account for up to 50 per cent of the body's weight and form the red flesh. Organized in groups and arranged in several layers, these muscles give the body its familiar form. The drawings below show the various different types of striated muscles, with the tendons at each end. Note the distinctive shape of the sphincter muscle on the far right.

Smooth (involuntary) muscles are confined to the walls of hollow organs, such as intestines and blood vessels. They function beyond our conscious control.

Cardiac (heart) muscles are both striated and involuntary, with a cell structure that ensures synchronic contraction.

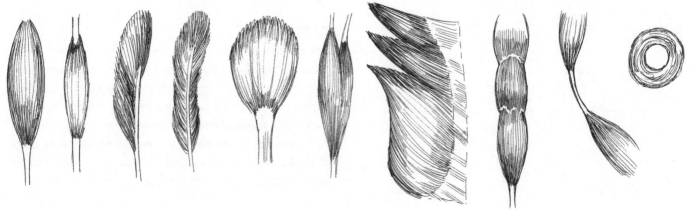

TENDONS

The tendons are fibrous structures that attach the ends of the muscles to the bones at protruding points called tubercles and tuberosities. Some muscles are divided by intervening tendons.

Tendons may be round and cord-like, or flat and band-like, consisting of strong tensile fibres arranged lengthwise. They are inextensible, allowing the muscles to pull hard against them. Many are longer than the muscles that they serve, such as in the forearm.

The aponeuroses are broad, flat, sheet-like tendons, a continuation of broad, flat muscles that either attach to the bone or continue into the fascia (see below); the tendinous arches are fibrous bands connected with the fasciae of muscles.

FASCIAE

These are fibrous laminae of various thicknesses, occurring in all parts of the body, enveloping all muscles, blood vessels, nerves, joints, organs and glands. They prevent friction between moving muscles.

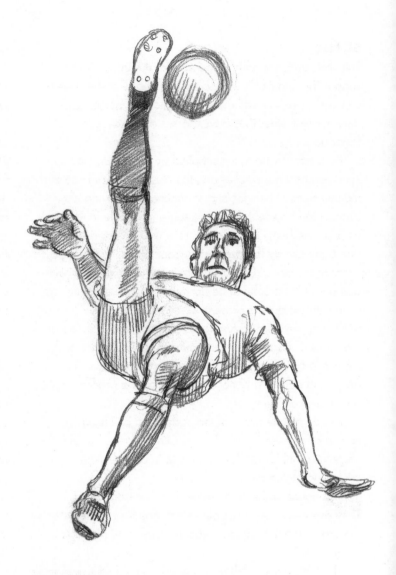

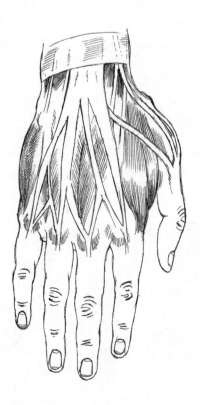

LIGAMENTS

These fibrous bands are situated at joints where articulated bones connect, or stretched between two immobile bones.

CARTILAGE

Cartilage is connective tissue composed of collagen (a protein). Fibrous cartilage forms the symphysis pubis (the joint between the pubic bones) and invertebral discs. Elastic cartilage gives shape to the outer flap of the ear. Hyaline cartilage – the most common form – covers the articular surface of bones (the ends near the joints); forms the rings of the trachea (windpipe) and the bronchi (airways) of the lungs; and gives shape to the lower ribcage and nose.

SKIN

A tough, self-replenishing membrane about 2 mm thick, skin defines the boundary between the internal and external environments. Human skin is thickest on the upper back, soles of the feet and palms of the hand; it is thinnest on the eyelids. Not only the body's largest sense organ, the skin also protects the body from abrasions, fluid loss and the penetration of harmful substances. Its other function is to regulate body temperature, through perspiration and the cooling effect of surface veins.

The skin has a top layer with the dermis beneath, a thicker layer of loose connective tissue. Beneath this is the hyperdermis, which is a fine layer of white connective fatty tissue, also called the superficial fascia.

FAT

Fat is the body's energy reserve. Its layers soften the contours of the skeletal-muscular frame. Although there are some gender differences as to where excess fat is accumulated, it is primarily stored around the buttocks, navel, hips, inner and outer thighs, front and back of knees, beneath the nipples, on the back of the arms, in the cheeks and below the jaw.

JOINTS

Joints form the connections between bones. In fibrous joints, such as sutures in the skull, there is no appreciable movement. There is limited movement in the cartilaginous joints. The most mobile are the synovial joints such as the knees, where the bones are not fixed.

The principal movements of the joints are flexion, which means bending to a more acute angle; extension, or straightening; adduction, which means moving towards the body's midline; abduction, moving away from the midline; and medial and lateral rotation (turning towards and away from the midline).

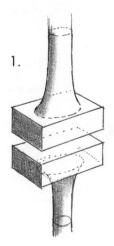 1.

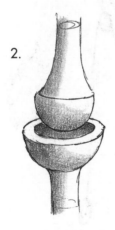 2.

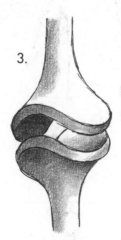 3.

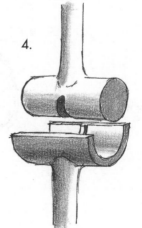 4.

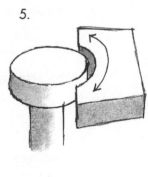 5.

1. PLANE JOINT
Formed by flat or slightly curved surfaces with little movement, such as the instep.

2. BALL AND SOCKET JOINT
The spherical edge of one bone moves in a spherical excavation of another, like the hip joint.

3. SADDLE OR BIAXIAL JOINT
Allows limited movement in two directions at right angles to each other, like the thumb.

4. HINGE JOINT
Bending and straightening movement is possible on one plane only, such as in the knee, the elbow and the finger.

5. PIVOT JOINT
One bone moves around another on its own axis, such as the radius and the ulna.

FULL-FIGURE SKELETON

Here we show three simple views of the skeleton, the front, the back and the side view (also called the anterior, the posterior and the lateral views). I have kept the number of bones named here to a minimum, since we will be going into greater detail when looking at the parts of the body in close-up.

Front view

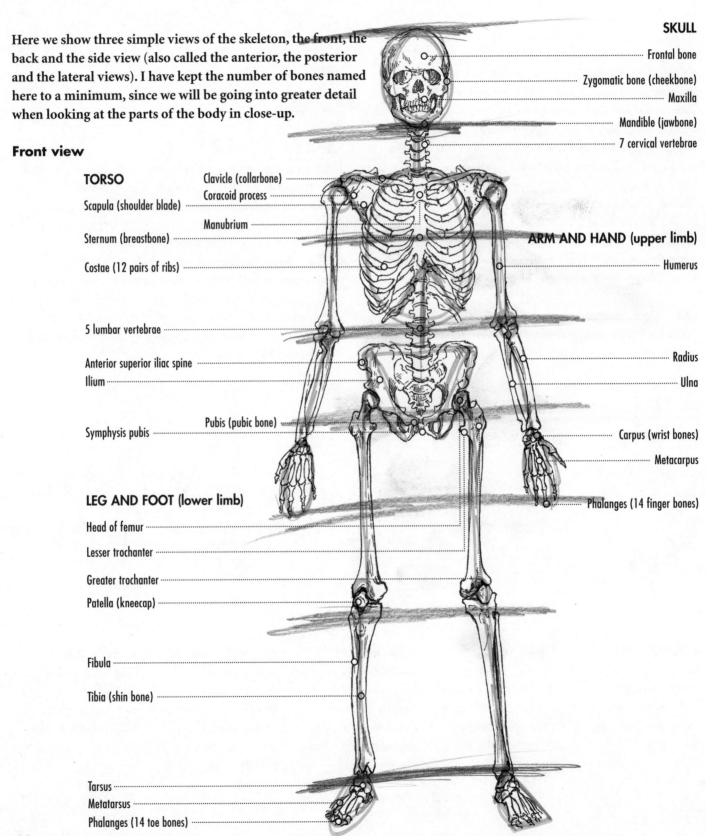

SKULL

Frontal bone

Zygomatic bone (cheekbone)

Maxilla

Mandible (jawbone)

7 cervical vertebrae

TORSO

Clavicle (collarbone)

Coracoid process

Scapula (shoulder blade)

Manubrium

Sternum (breastbone)

Costae (12 pairs of ribs)

ARM AND HAND (upper limb)

Humerus

5 lumbar vertebrae

Anterior superior iliac spine

Ilium

Radius

Ulna

Symphysis pubis

Pubis (pubic bone)

Carpus (wrist bones)

Metacarpus

LEG AND FOOT (lower limb)

Phalanges (14 finger bones)

Head of femur

Lesser trochanter

Greater trochanter

Patella (kneecap)

Fibula

Tibia (shin bone)

Tarsus

Metatarsus

Phalanges (14 toe bones)

10

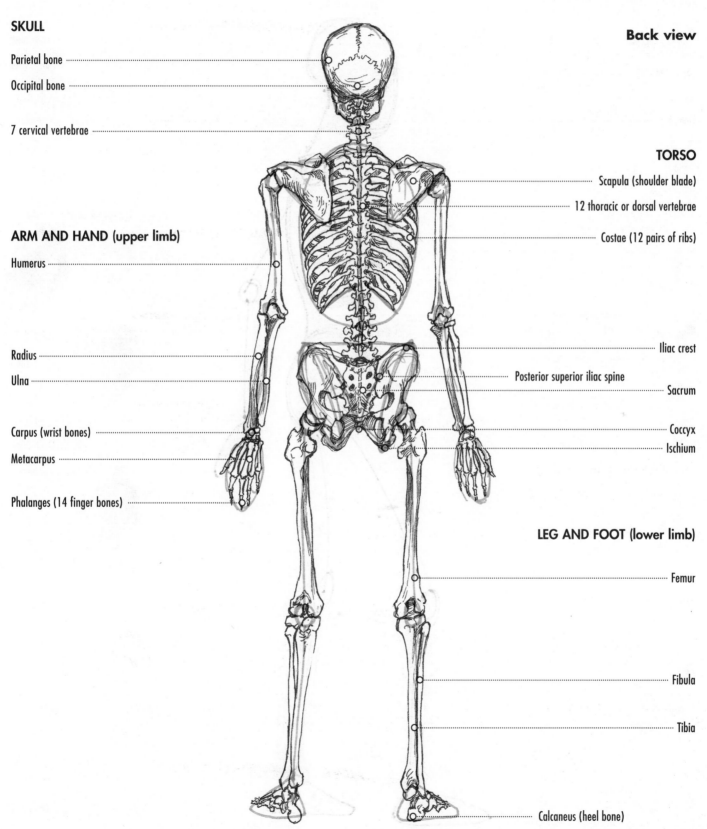

SKULL

Parietal bone

Occipital bone

7 cervical vertebrae

Back view

TORSO

Scapula (shoulder blade)

12 thoracic or dorsal vertebrae

Costae (12 pairs of ribs)

ARM AND HAND (upper limb)

Humerus

Radius

Ulna

Carpus (wrist bones)

Metacarpus

Phalanges (14 finger bones)

Iliac crest

Posterior superior iliac spine

Sacrum

Coccyx

Ischium

LEG AND FOOT (lower limb)

Femur

Fibula

Tibia

Calcaneus (heel bone)

11

FULL-FIGURE SKELETON

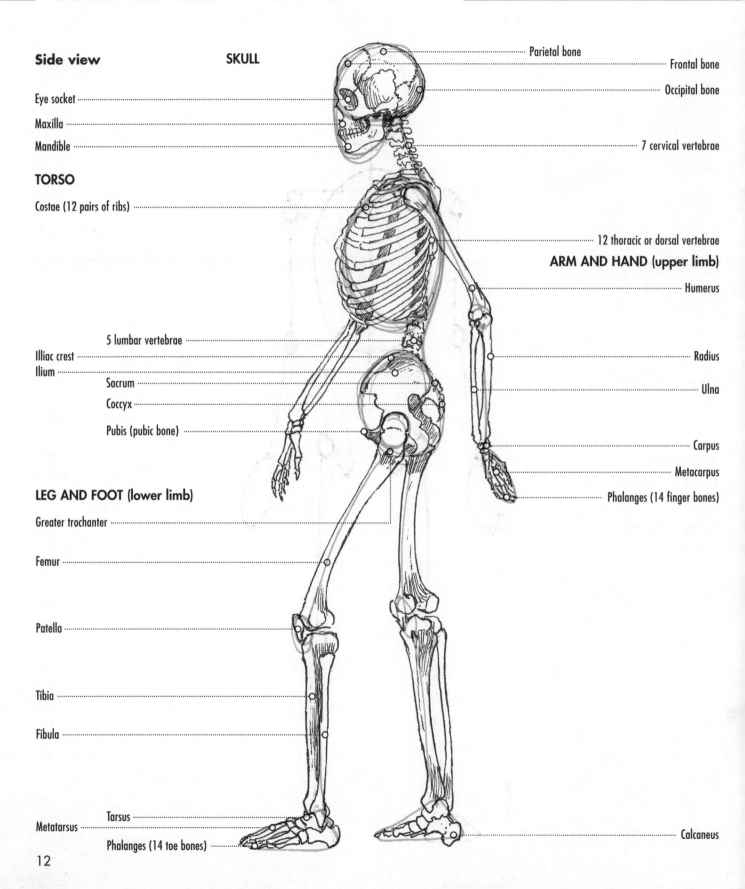

Side view

SKULL

Eye socket

Maxilla

Mandible

TORSO

Costae (12 pairs of ribs)

5 lumbar vertebrae

Illiac crest

Ilium

Sacrum

Coccyx

Pubis (pubic bone)

LEG AND FOOT (lower limb)

Greater trochanter

Femur

Patella

Tibia

Fibula

Metatarsus

Tarsus

Phalanges (14 toe bones)

Parietal bone

Frontal bone

Occipital bone

7 cervical vertebrae

12 thoracic or dorsal vertebrae

ARM AND HAND (upper limb)

Humerus

Radius

Ulna

Carpus

Metacarpus

Phalanges (14 finger bones)

Calcaneus

FULL-FIGURE MUSCULATURE

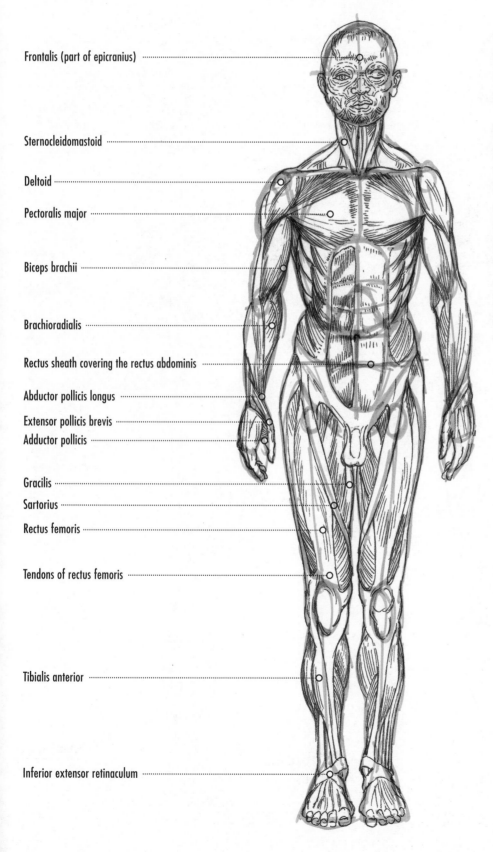

Frontalis (part of epicranius)

Sternocleidomastoid

Deltoid

Pectoralis major

Biceps brachii

Brachioradialis

Rectus sheath covering the rectus abdominis

Abductor pollicis longus

Extensor pollicis brevis
Adductor pollicis

Gracilis

Sartorius

Rectus femoris

Tendons of rectus femoris

Tibialis anterior

Inferior extensor retinaculum

We show here the musculature of the whole body, so as to give some idea of the complexity of the sheaths of muscles over the bone structure.

The drawings that follow are based on a male body. Of course there are slight differences between the male and female musculature, but not much in the underlying structure. The main differences are in the chest and pubic areas. There are also slight proportional differences which we will look at later, but this complete figure of the muscles of a human being will give you a good idea as to how the muscles are placed over the body.

FULL-FIGURE MUSCULATURE

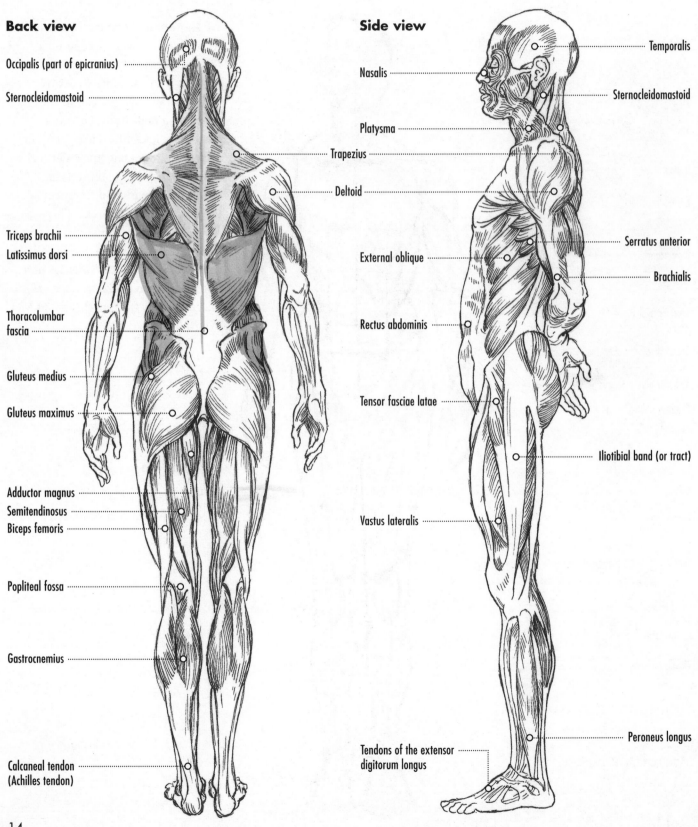

Back view

Occipalis (part of epicranius)

Sternocleidomastoid

Triceps brachii

Latissimus dorsi

Thoracolumbar fascia

Gluteus medius

Gluteus maximus

Adductor magnus

Semitendinosus

Biceps femoris

Popliteal fossa

Gastrocnemius

Calcaneal tendon (Achilles tendon)

Side view

Nasalis

Platysma

Trapezius

Deltoid

External oblique

Rectus abdominis

Tensor fasciae latae

Vastus lateralis

Tendons of the extensor digitorum longus

Temporalis

Sternocleidomastoid

Serratus anterior

Brachialis

Iliotibial band (or tract)

Peroneus longus

14

FULL-FIGURE BODY

When you come to examine the surface of the human body, all the bones and muscles we have looked at are rather disguised by the layers of fat and skin that cover them. For the artist this becomes a sort of detective story, through the process of working out which bulges and hollows represent which features underneath the skin.

To make this easier, I have shown drawings of the body from the front and back, which are in a way as diagrammatic as the skeletal and the muscular figures in the previous pages. Because, on the surface, the male and female shapes become more differentiated, I have drawn both sexes. I have also included diagrams of the proportions of figures (see pages 18–19), to make it easier for you to draw the figure correctly.

However, I cannot stress enough that to draw the human figure effectively, you will eventually need to attend a life class at a local arts facility. Drawing from others' drawings and diagrams is useful, as is working from photographs, but you will never make entirely convincing drawings of people unless you also draw from life.

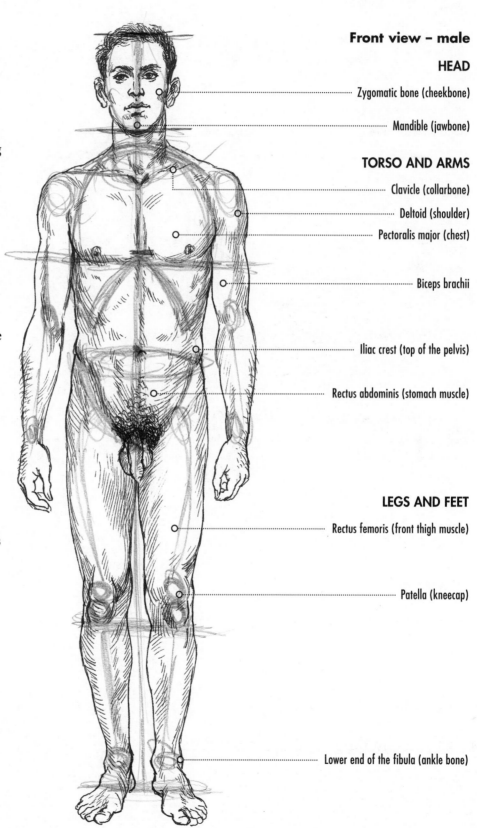

Front view – male

HEAD

Zygomatic bone (cheekbone)

Mandible (jawbone)

TORSO AND ARMS

Clavicle (collarbone)

Deltoid (shoulder)

Pectoralis major (chest)

Biceps brachii

Iliac crest (top of the pelvis)

Rectus abdominis (stomach muscle)

LEGS AND FEET

Rectus femoris (front thigh muscle)

Patella (kneecap)

Lower end of the fibula (ankle bone)

FULL-FIGURE BODY

Front view – female

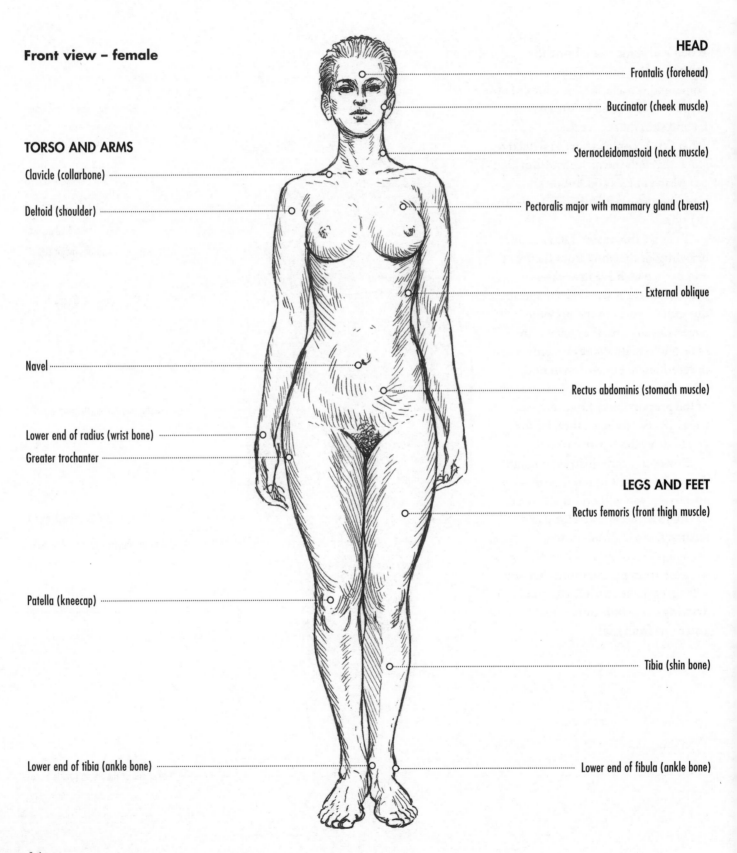

HEAD

Frontalis (forehead)

Buccinator (cheek muscle)

Sternocleidomastoid (neck muscle)

Pectoralis major with mammary gland (breast)

External oblique

Rectus abdominis (stomach muscle)

TORSO AND ARMS

Clavicle (collarbone)

Deltoid (shoulder)

Navel

Lower end of radius (wrist bone)

Greater trochanter

LEGS AND FEET

Rectus femoris (front thigh muscle)

Patella (kneecap)

Tibia (shin bone)

Lower end of tibia (ankle bone)

Lower end of fibula (ankle bone)

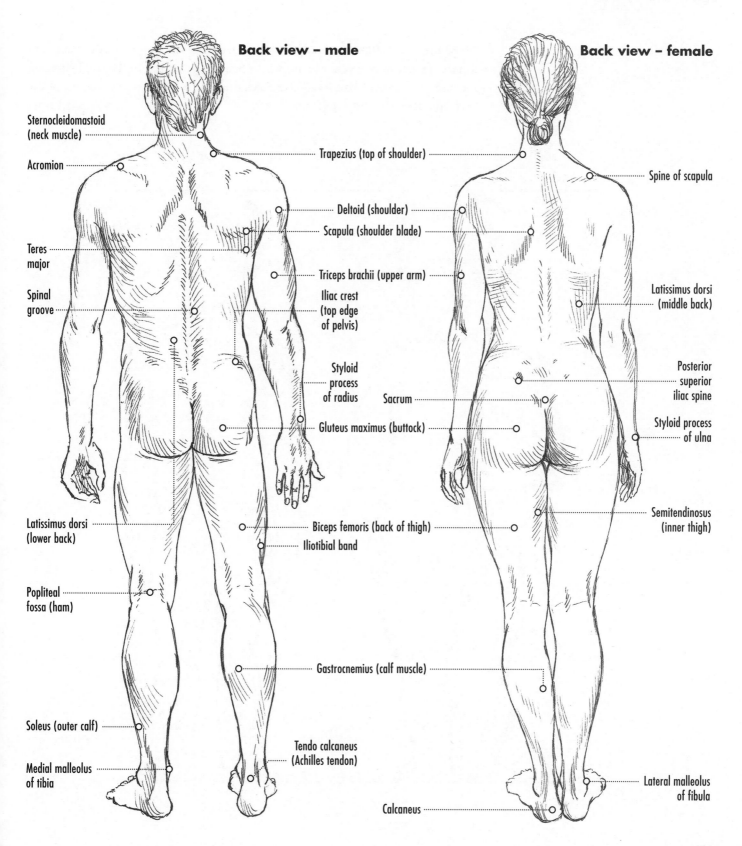

Back view – male

Back view – female

Sternocleidomastoid (neck muscle)

Acromion

Teres major

Spinal groove

Latissimus dorsi (lower back)

Popliteal fossa (ham)

Soleus (outer calf)

Medial malleolus of tibia

Trapezius (top of shoulder)

Deltoid (shoulder)

Scapula (shoulder blade)

Triceps brachii (upper arm)

Iliac crest (top edge of pelvis)

Styloid process of radius

Gluteus maximus (buttock)

Biceps femoris (back of thigh)

Iliotibial band

Gastrocnemius (calf muscle)

Tendo calcaneus (Achilles tendon)

Calcaneus

Spine of scapula

Latissimus dorsi (middle back)

Posterior superior iliac spine

Styloid process of ulna

Sacrum

Semitendinosus (inner thigh)

Lateral malleolus of fibula

PROPORTIONS AT DIFFERENT AGES

These drawings show the changes in proportion of the human body (male) at different ages. At one year old, only four head lengths fit into the full height of the body, whereas at almost 25 years old, the head will go into the length of the body about seven and a half times.

1 Year

4 Years

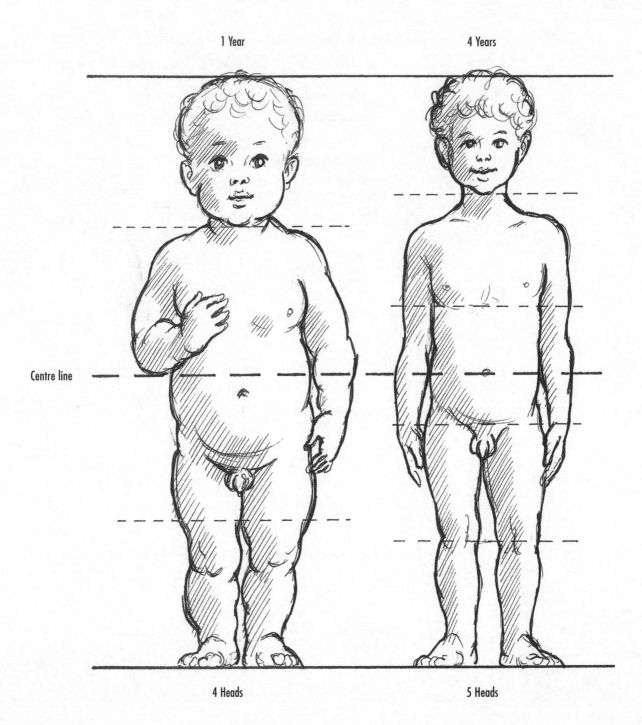

Centre line

4 Heads

5 Heads

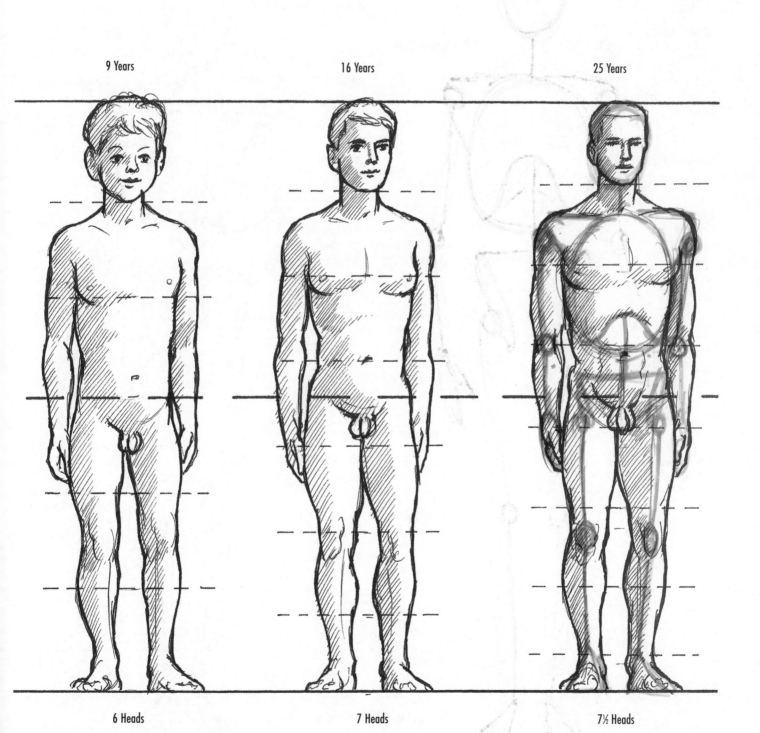

9 Years

16 Years

25 Years

6 Heads

7 Heads

7½ Heads

THE MALE AND FEMALE SKELETON

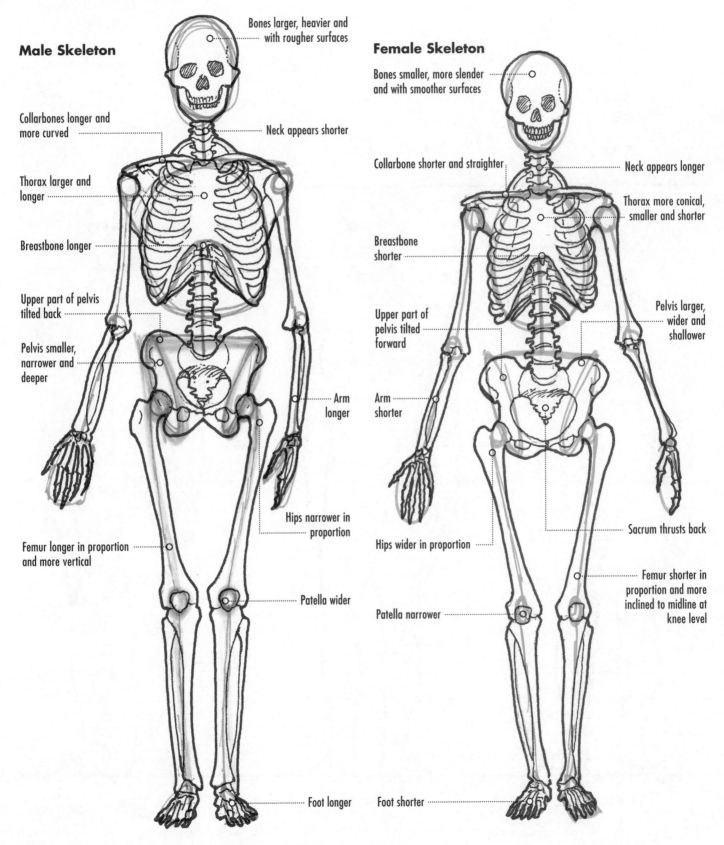

Male Skeleton

Bones larger, heavier and with rougher surfaces

Collarbones longer and more curved

Neck appears shorter

Thorax larger and longer

Breastbone longer

Upper part of pelvis tilted back

Pelvis smaller, narrower and deeper

Arm longer

Hips narrower in proportion

Femur longer in proportion and more vertical

Patella wider

Foot longer

Female Skeleton

Bones smaller, more slender and with smoother surfaces

Collarbone shorter and straighter

Neck appears longer

Thorax more conical, smaller and shorter

Breastbone shorter

Upper part of pelvis tilted forward

Pelvis larger, wider and shallower

Arm shorter

Sacrum thrusts back

Hips wider in proportion

Femur shorter in proportion and more inclined to midline at knee level

Patella narrower

Foot shorter

THE FULL FIGURE: MASTER ARTIST

After Ingres (1780–1867)

Art students of earlier centuries learned their craft by working in the studios of their masters; later, students would copy paintings in the great art galleries of the world. Studying the works of the masters remains an invaluable process.

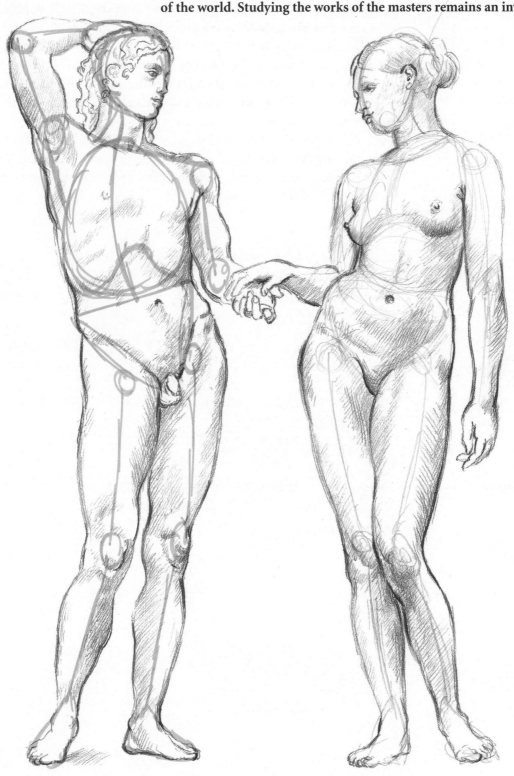

THE SKULL

The upper part of the skull contains the brain and the organs of sight and hearing. The front and rear parts consist of the thickest bone, where impacts are most likely; the sides of the head are much thinner. There are various openings in the casing of the skull such as the ear holes and the eye sockets, which contain smaller apertures for the passage of the optic nerves to the brain. In the middle of the skull is the foramen magnum, through which the spinal column passes and connections are maintained between the brain and the rest of the body.

The lower part of the skull is the mandible, which houses the lower teeth and is hinged at the sides of the upper skull just below the ears. The first (milk) teeth fall out during childhood and are replaced by much larger adult teeth, which fill the growing jaw.

Front view

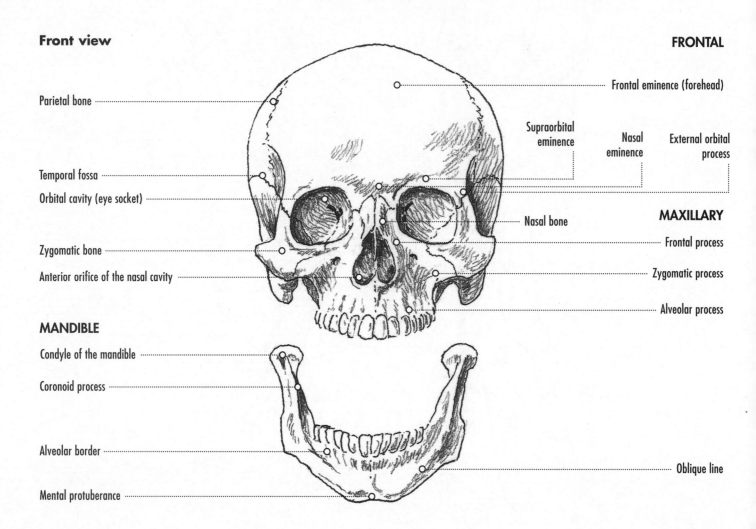

FRONTAL

Frontal eminence (forehead)

Parietal bone

Supraorbital eminence

Nasal eminence

External orbital process

Temporal fossa

Orbital cavity (eye socket)

Nasal bone

MAXILLARY

Zygomatic bone

Frontal process

Anterior orifice of the nasal cavity

Zygomatic process

Alveolar process

MANDIBLE

Condyle of the mandible

Coronoid process

Alveolar border

Oblique line

Mental protuberance

22

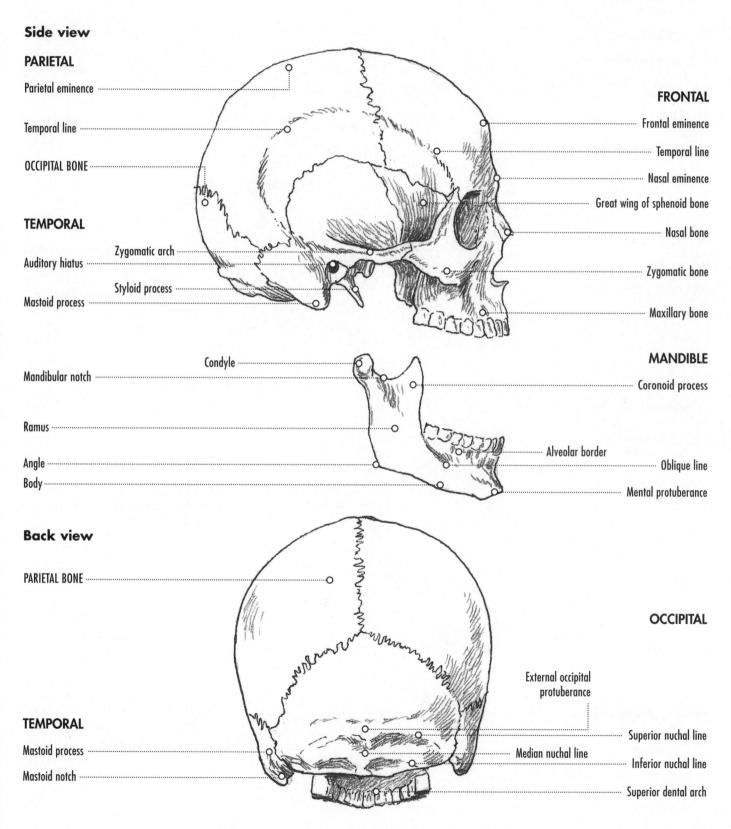

Side view

PARIETAL

Parietal eminence

Temporal line

OCCIPITAL BONE

TEMPORAL

Auditory hiatus

Mastoid process

Zygomatic arch

Styloid process

FRONTAL

Frontal eminence

Temporal line

Nasal eminence

Great wing of sphenoid bone

Nasal bone

Zygomatic bone

Maxillary bone

Condyle

Mandibular notch

Ramus

Angle
Body

MANDIBLE

Coronoid process

Alveolar border

Oblique line

Mental protuberance

Back view

PARIETAL BONE

TEMPORAL

Mastoid process

Mastoid notch

OCCIPITAL

External occipital
protuberance

Superior nuchal line

Median nuchal line

Inferior nuchal line

Superior dental arch

23

THE MALE, FEMALE AND INFANT SKULL

Male skull

Larger and heavier than the female

Contours rougher

Parietal bone

Temporal bone

Occipital bone

Occipital protuberance more prominent

Auditory canal

Mastoid process larger

Angle of mandible squarer

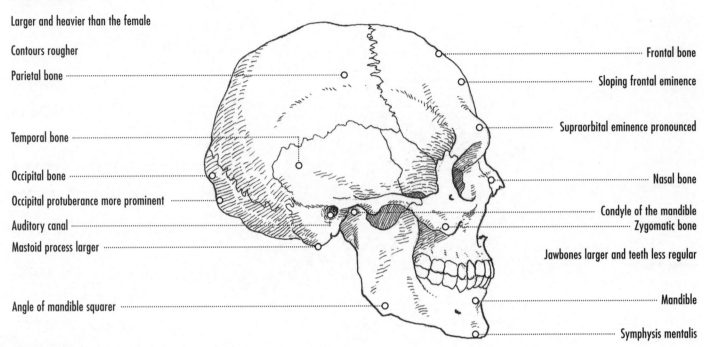

Frontal bone

Sloping frontal eminence

Supraorbital eminence pronounced

Nasal bone

Condyle of the mandible

Zygomatic bone

Jawbones larger and teeth less regular

Mandible

Symphysis mentalis

Female skull

Smaller, lighter and smoother than the male skull

Contours rounder and smoother

Mastoid process smaller

Angle of mandible less pronounced

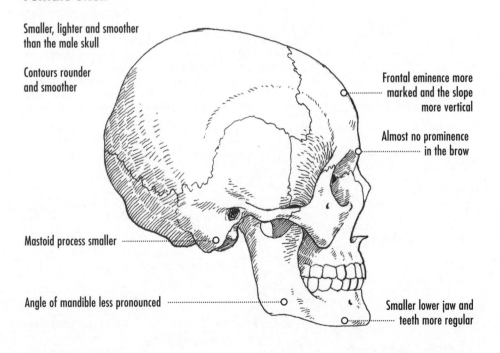

Frontal eminence more marked and the slope more vertical

Almost no prominence in the brow

Smaller lower jaw and teeth more regular

Infant skull

The main difference between the infant skull and the adult one is the smaller size of the face compared with the cranium.

The upper and lower jaws are much smaller due to not having any teeth. As teeth appear, the jaw grows.

MUSCLES OF THE HEAD

These are the muscles that enable us to eat and drink, and of course they surround our organs of sight, sound, smell and taste. Although they don't have the physical power of the larger muscles of the limbs and trunk, they do play an important part in our lives.

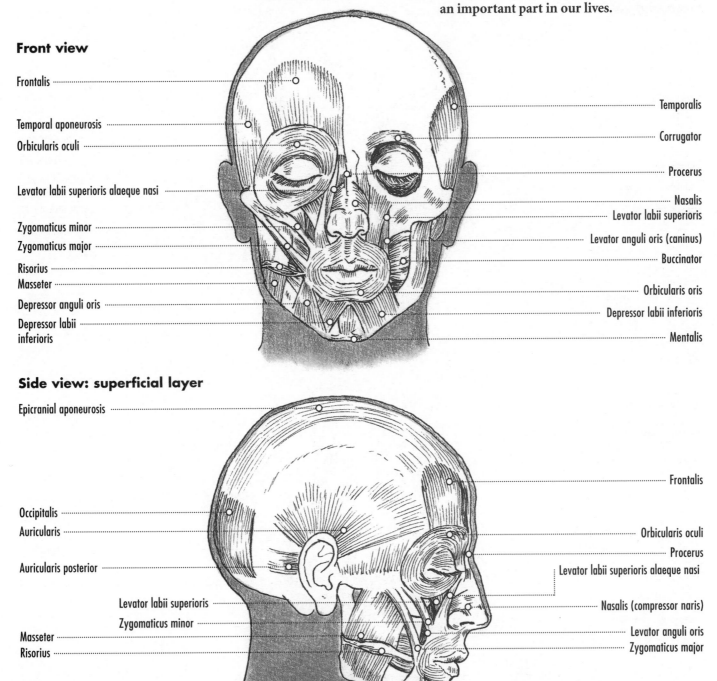

Front view

Frontalis

Temporal aponeurosis

Orbicularis oculi

Levator labii superioris alaeque nasi

Zygomaticus minor

Zygomaticus major

Risorius

Masseter

Depressor anguli oris

Depressor labii inferioris

Temporalis

Corrugator

Procerus

Nasalis

Levator labii superioris

Levator anguli oris (caninus)

Buccinator

Orbicularis oris

Depressor labii inferioris

Mentalis

Side view: superficial layer

Epicranial aponeurosis

Occipitalis

Auricularis

Auricularis posterior

Levator labii superioris

Zygomaticus minor

Masseter

Risorius

Depressor anguli oris

Frontalis

Orbicularis oculi

Procerus

Levator labii superioris alaeque nasi

Nasalis (compressor naris)

Levator anguli oris

Zygomaticus major

Depressor labii inferioris

Mentalis

25

MUSCLES OF THE NECK

The muscles of the neck are included with those of the head because, in most respects, their effect can be closely aligned with the head structure.

Front and side view

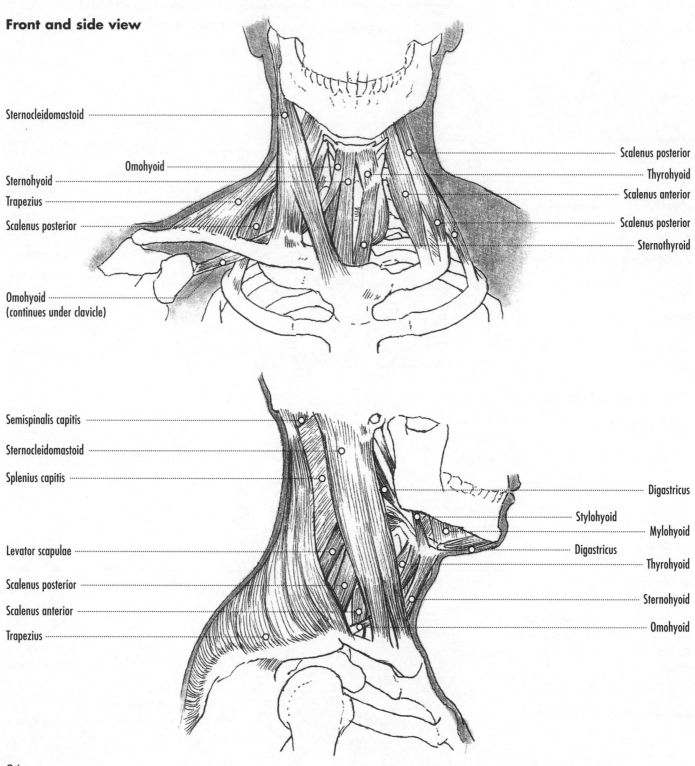

Sternocleidomastoid

Omohyoid

Sternohyoid

Trapezius

Scalenus posterior

Omohyoid
(continues under clavicle)

Scalenus posterior

Thyrohyoid

Scalenus anterior

Scalenus posterior

Sternothyroid

Semispinalis capitis

Sternocleidomastoid

Splenius capitis

Levator scapulae

Scalenus posterior

Scalenus anterior

Trapezius

Digastricus

Stylohyoid

Mylohyoid

Digastricus

Thyrohyoid

Sternohyoid

Omohyoid

THE HEAD: MASTER ARTISTS

**After Michelangelo
(1475–1564)**

The groups of head and neck muscles we have identified can be seen in these drawings by Michelangelo and Peter Paul Rubens. It is interesting to note that as soon as you start to look for the muscles of the face, they become clearer and it is easier to draw them correctly.

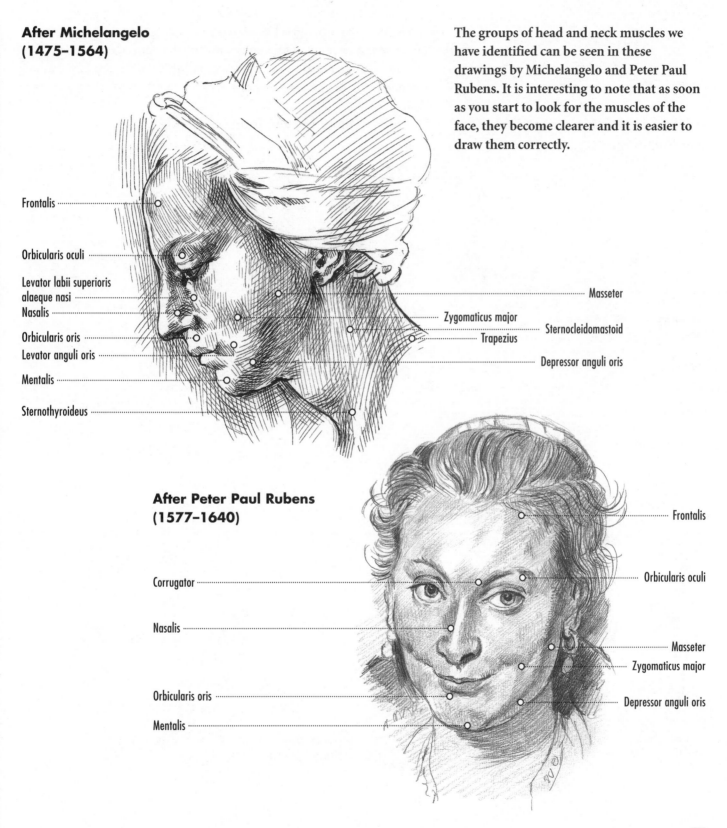

Frontalis

Orbicularis oculi

Levator labii superioris
alaeque nasi

Nasalis

Orbicularis oris

Levator anguli oris

Mentalis

Sternothyroideus

Masseter

Zygomaticus major

Sternocleidomastoid

Trapezius

Depressor anguli oris

**After Peter Paul Rubens
(1577–1640)**

Corrugator

Nasalis

Orbicularis oris

Mentalis

Frontalis

Orbicularis oculi

Masseter

Zygomaticus major

Depressor anguli oris

27

FACIAL EXPRESSIONS

Now we move on to the other great challenge of drawing the head: capturing expression. Here is a series of expressions showing the dominant muscles. Check them and then persuade your friends or family to make similar faces to see if you can identify the muscles responsible.

Muscles used when smiling, grinning and laughing

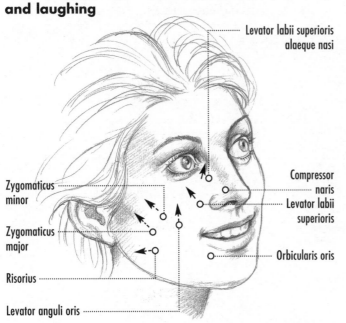

Levator labii superioris alaeque nasi

Compressor naris

Levator labii superioris

Orbicularis oris

Zygomaticus minor

Zygomaticus major

Risorius

Levator anguli oris

Shouting out loud

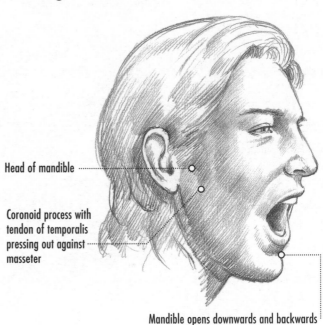

Head of mandible

Coronoid process with tendon of temporalis pressing out against masseter

Mandible opens downwards and backwards

Filling cheeks with air to blow

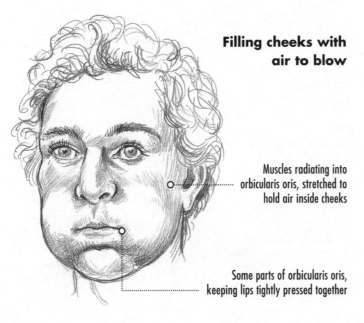

Muscles radiating into orbicularis oris, stretched to hold air inside cheeks

Some parts of orbicularis oris, keeping lips tightly pressed together

Flirting

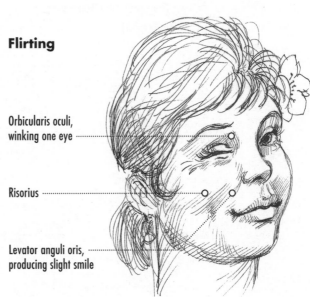

Orbicularis oculi, winking one eye

Risorius

Levator anguli oris, producing slight smile

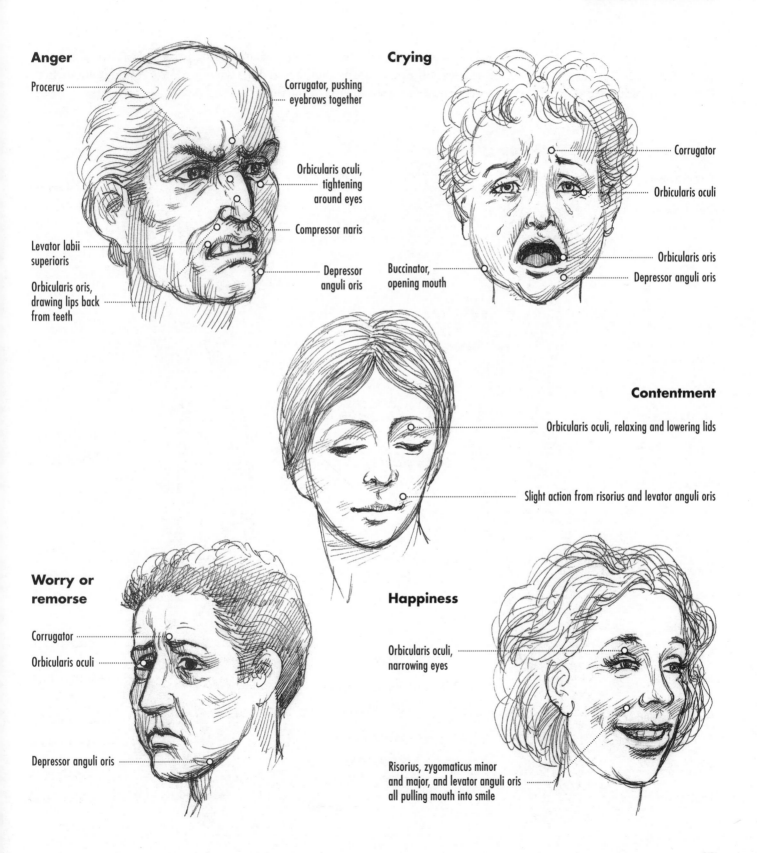

Anger

Procerus

Corrugator, pushing eyebrows together

Orbicularis oculi, tightening around eyes

Compressor naris

Levator labii superioris

Depressor anguli oris

Orbicularis oris, drawing lips back from teeth

Crying

Corrugator

Orbicularis oculi

Orbicularis oris

Buccinator, opening mouth

Depressor anguli oris

Contentment

Orbicularis oculi, relaxing and lowering lids

Slight action from risorius and levator anguli oris

Worry or remorse

Corrugator

Orbicularis oculi

Depressor anguli oris

Happiness

Orbicularis oculi, narrowing eyes

Risorius, zygomaticus minor and major, and levator anguli oris all pulling mouth into smile

29

SKELETON OF THE ARM AND HAND

The bone structure of the arm appears quite straightforward at first glance. However, the areas of the shoulder and the wrist are fairly complex and help to allow the many movements of the limb.

Front and back view

Clavicle

Head of humerus

Greater tuberosity (or tubercle)

Scapula

Clavicle

Head of humerus

Humerus

Lateral epicondyle

Capitulum

Head of radius

Medial epicondyle

Olecranon

Coronoid process

Lateral epicondyle

Head of radius

Radius

Ulna

Radius

Styloid process

Lunate carpal

Scaphoid carpal

Trapezium carpal

First metacarpal

Proximal phalange

Distal phalange

Trapezoid carpal

Capitate carpal

Pisiform carpal

Triangular carpal

Hamate carpal

Fifth metacarpal

Proximal phalange

Middle phalange

Distal phalange

Lunate carpal

Scaphoid carpal

Trapezium carpal

First metacarpal

Proximal phalange

Distal phalange

Trapezoid carpal

Capitate carpal

MUSCLES OF THE ARM AND HAND

Front and back view

Notice the complexity of the interleaving muscles around the shoulder and elbow, and the long strands of tendons passing through the wrist. The bone structure is most obvious on the hand.

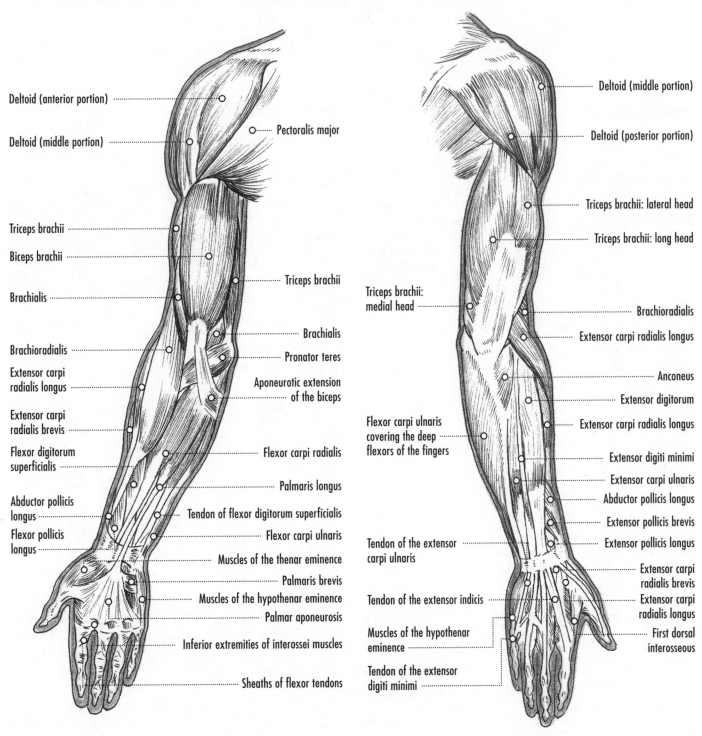

Deltoid (anterior portion)

Deltoid (middle portion)

Pectoralis major

Triceps brachii

Biceps brachii

Brachialis

Triceps brachii

Brachialis

Pronator teres

Brachioradialis

Aponeurotic extension of the biceps

Extensor carpi radialis longus

Extensor carpi radialis brevis

Flexor digitorum superficialis

Flexor carpi radialis

Abductor pollicis longus

Tendon of flexor digitorum superficialis

Flexor pollicis longus

Flexor carpi ulnaris

Muscles of the thenar eminence

Palmaris brevis

Muscles of the hypothenar eminence

Palmar aponeurosis

Inferior extremities of interossei muscles

Sheaths of flexor tendons

Palmaris longus

Deltoid (middle portion)

Deltoid (posterior portion)

Triceps brachii: lateral head

Triceps brachii: long head

Triceps brachii: medial head

Brachioradialis

Extensor carpi radialis longus

Anconeus

Extensor digitorum

Extensor carpi radialis longus

Flexor carpi ulnaris covering the deep flexors of the fingers

Extensor digiti minimi

Extensor carpi ulnaris

Abductor pollicis longus

Extensor pollicis brevis

Tendon of the extensor carpi ulnaris

Extensor pollicis longus

Extensor carpi radialis brevis

Tendon of the extensor indicis

Extensor carpi radialis longus

First dorsal interosseous

Muscles of the hypothenar eminence

Tendon of the extensor digiti minimi

SKELETON OF THE HAND

As well as combined drawings of the arm and hand, I am also dealing with the hand separately because it is such an intricate part of the upper limb. These diagrams of the bones of the hand seen from two different angles are well worth studying, so you will be able to recognize them through the covering of muscle and skin.

Palm-down view

Palm-up view

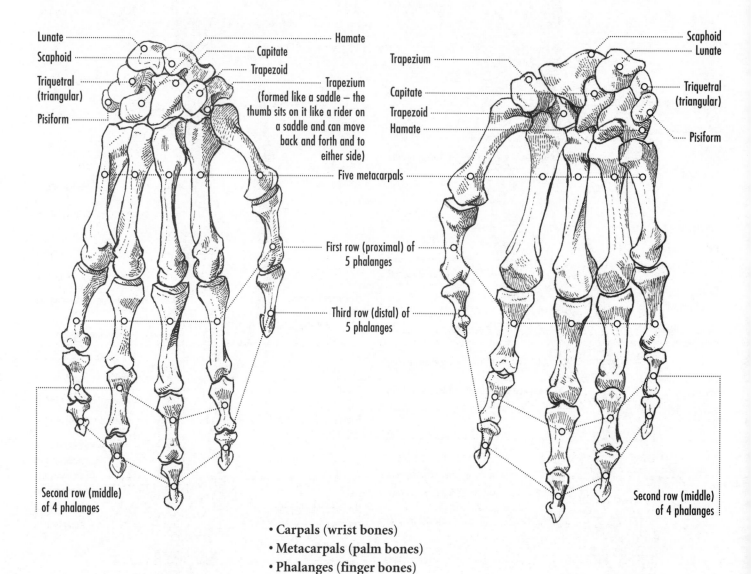

Palm-down view labels:
Lunate
Scaphoid
Triquetral (triangular)
Pisiform
Hamate
Capitate
Trapezoid
Trapezium (formed like a saddle – the thumb sits on it like a rider on a saddle and can move back and forth and to either side)
Five metacarpals
First row (proximal) of 5 phalanges
Third row (distal) of 5 phalanges
Second row (middle) of 4 phalanges

Palm-up view labels:
Trapezium
Capitate
Trapezoid
Hamate
Scaphoid
Lunate
Triquetral (triangular)
Pisiform
Second row (middle) of 4 phalanges

• Carpals (wrist bones)
• Metacarpals (palm bones)
• Phalanges (finger bones)

MUSCLES OF THE HAND

The hand, being the part of the body which sets human skills apart from all the other animals, is a very complex structure of overlapping muscles and tendons. These allow the fingers and thumb to perform very complicated and subtle motions, enabling humans to construct and handle an enormous number of tools (including a pencil), extending their range of activities far beyond that of other species.

Palm-up view

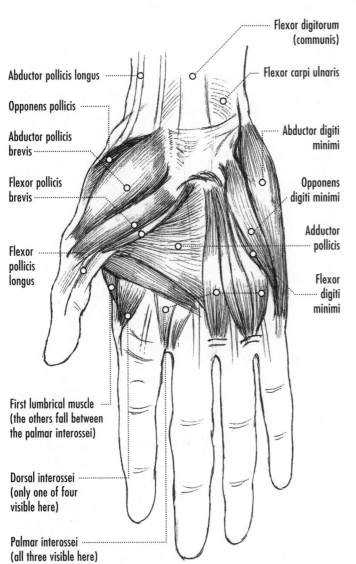

Abductor pollicis longus

Opponens pollicis

Abductor pollicis brevis

Flexor pollicis brevis

Flexor pollicis longus

Flexor digitorum (communis)

Flexor carpi ulnaris

Abductor digiti minimi

Opponens digiti minimi

Adductor pollicis

Flexor digiti minimi

First lumbrical muscle (the others fall between the palmar interossei)

Dorsal interossei (only one of four visible here)

Palmar interossei (all three visible here)

Palm-down view

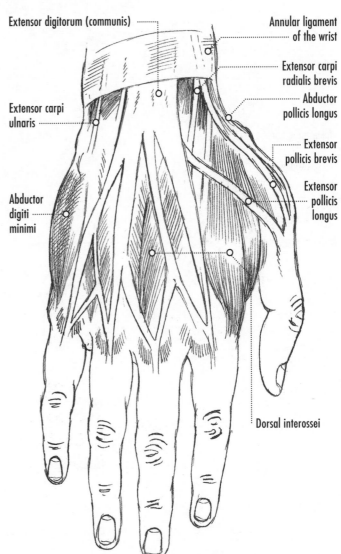

Extensor digitorum (communis)

Extensor carpi ulnaris

Abductor digiti minimi

Annular ligament of the wrist

Extensor carpi radialis brevis

Abductor pollicis longus

Extensor pollicis brevis

Extensor pollicis longus

Dorsal interossei

SURFACE OF THE HAND

Palm-up view

The views shown here are of male hands. The female hand is usually softer-looking and with more tapered fingers, while the knuckles of the male hand tend to look more prominent and the fingers squarer in shape. But don't take this for granted when drawing hands; sometimes this typical shape can be reversed.

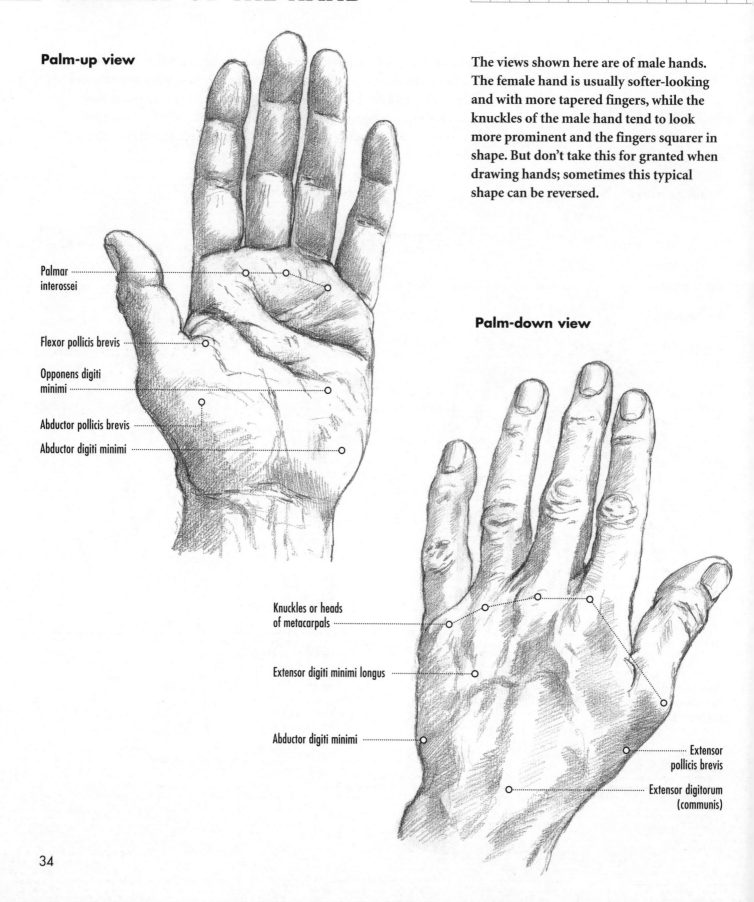

Palmar interossei

Flexor pollicis brevis

Opponens digiti minimi

Abductor pollicis brevis

Abductor digiti minimi

Palm-down view

Knuckles or heads of metacarpals

Extensor digiti minimi longus

Abductor digiti minimi

Extensor pollicis brevis

Extensor digitorum (communis)

SURFACE OF THE ARM AND HAND

When the arm is stretched out horizontally, we can see the shapes of the larger muscles at the surface of the limb. Here we look at the outstretched arm from two angles: with the palm facing up (supine view) and with the palm facing down (prone view).

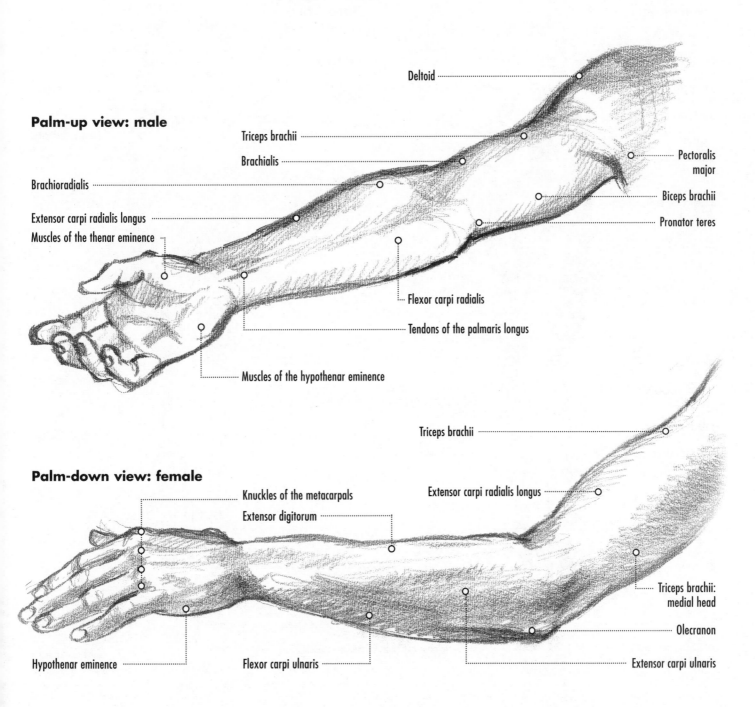

Palm-up view: male

Deltoid

Triceps brachii

Brachialis

Brachioradialis

Extensor carpi radialis longus

Muscles of the thenar eminence

Pectoralis major

Biceps brachii

Pronator teres

Flexor carpi radialis

Tendons of the palmaris longus

Muscles of the hypothenar eminence

Triceps brachii

Palm-down view: female

Knuckles of the metacarpals

Extensor digitorum

Extensor carpi radialis longus

Triceps brachii: medial head

Olecranon

Hypothenar eminence

Flexor carpi ulnaris

Extensor carpi ulnaris

35

SKELETON OF THE LEG

The skeleton of the lower limb is composed of much longer, stronger bones than the upper limb. The femur is the longest and largest bone in the human body and is the classic shape that we think of when we visualize a bone.

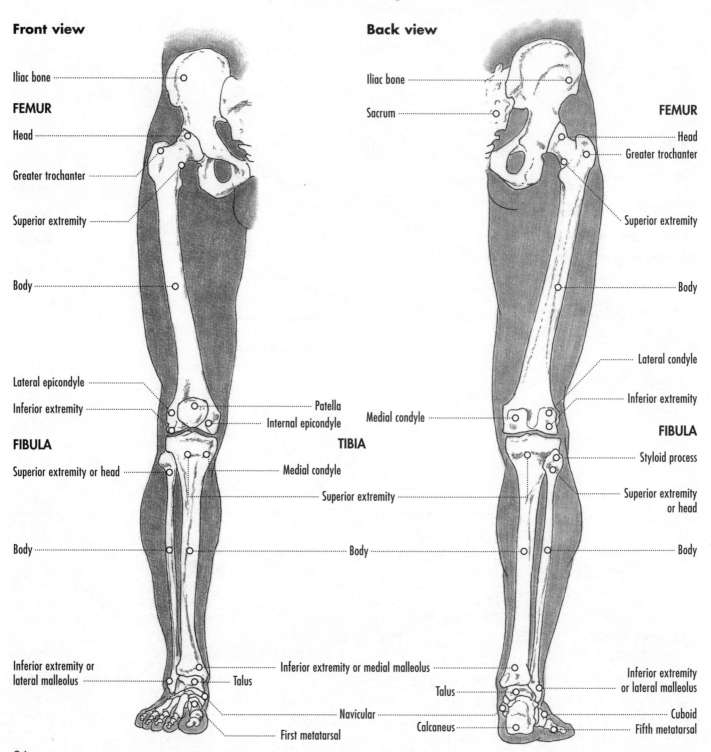

Front view

Iliac bone

FEMUR

Head

Greater trochanter

Superior extremity

Body

Lateral epicondyle

Inferior extremity

Patella
Internal epicondyle

FIBULA

Superior extremity or head

Medial condyle

Superior extremity

Body

Body

Inferior extremity or
lateral malleolus

Talus

Inferior extremity or medial malleolus

Navicular

First metatarsal

Back view

Iliac bone

Sacrum

FEMUR

Head
Greater trochanter

Superior extremity

Body

Lateral condyle

Inferior extremity

FIBULA

Styloid process

Superior extremity
or head

Body

Medial condyle

TIBIA

Talus

Calcaneus

Inferior extremity
or lateral malleolus

Cuboid

Fifth metatarsal

MUSCLES OF THE LEG

Like the upper limbs, the legs are wrapped in long, layered muscles that help to give flexibility. However, because of the increased strength needed to support the rest of the body's weight, the leg muscles tend to be longer and bigger.

I have included the band of fascia running down the side of the leg over the muscles (the fascia lata and the iliotibial band) and the band of Richer which holds the muscles in at the front of the thigh.

Front view

Back view

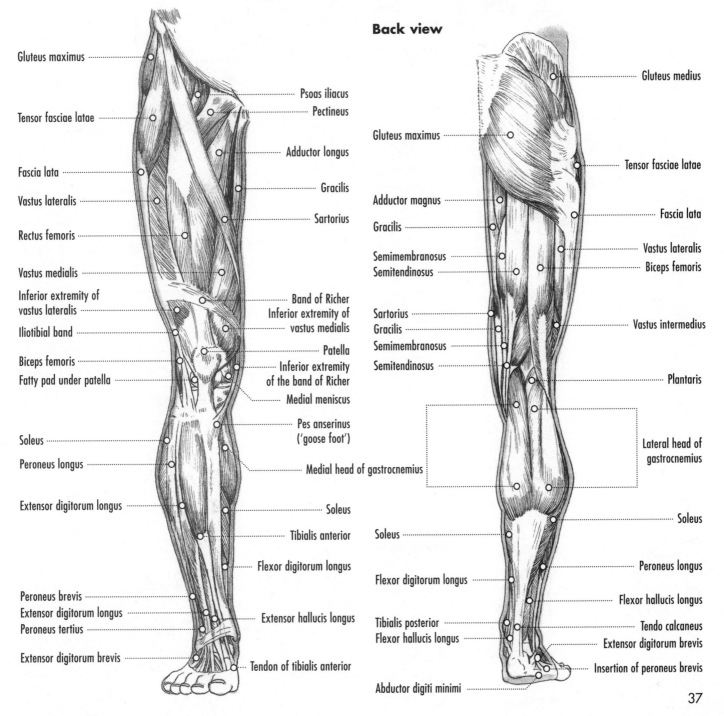

Gluteus maximus

Tensor fasciae latae

Fascia lata

Vastus lateralis

Rectus femoris

Vastus medialis

Inferior extremity of vastus lateralis

Iliotibial band

Biceps femoris

Fatty pad under patella

Soleus

Peroneus longus

Extensor digitorum longus

Peroneus brevis
Extensor digitorum longus
Peroneus tertius

Extensor digitorum brevis

Psoas iliacus
Pectineus

Adductor longus

Gracilis

Sartorius

Band of Richer
Inferior extremity of vastus medialis

Patella
Inferior extremity of the band of Richer

Medial meniscus

Pes anserinus ('goose foot')

Medial head of gastrocnemius

Soleus

Tibialis anterior

Flexor digitorum longus

Extensor hallucis longus

Tendon of tibialis anterior

Gluteus maximus

Adductor magnus

Gracilis

Semimembranosus
Semitendinosus

Sartorius
Gracilis
Semimembranosus
Semitendinosus

Soleus

Flexor digitorum longus

Tibialis posterior
Flexor hallucis longus

Abductor digiti minimi

Gluteus medius

Tensor fasciae latae

Fascia lata

Vastus lateralis
Biceps femoris

Vastus intermedius

Plantaris

Lateral head of gastrocnemius

Soleus

Peroneus longus

Flexor hallucis longus

Tendo calcaneus
Extensor digitorum brevis
Insertion of peroneus brevis

SURFACE OF THE LEG

The large muscles are the only ones easily seen and the only bone structure visible is at the knee and ankle. However, the tibia (shin bone) creates a long, smooth surface at the front of the lower leg that is noticeable.

Back view: male

Front view: female

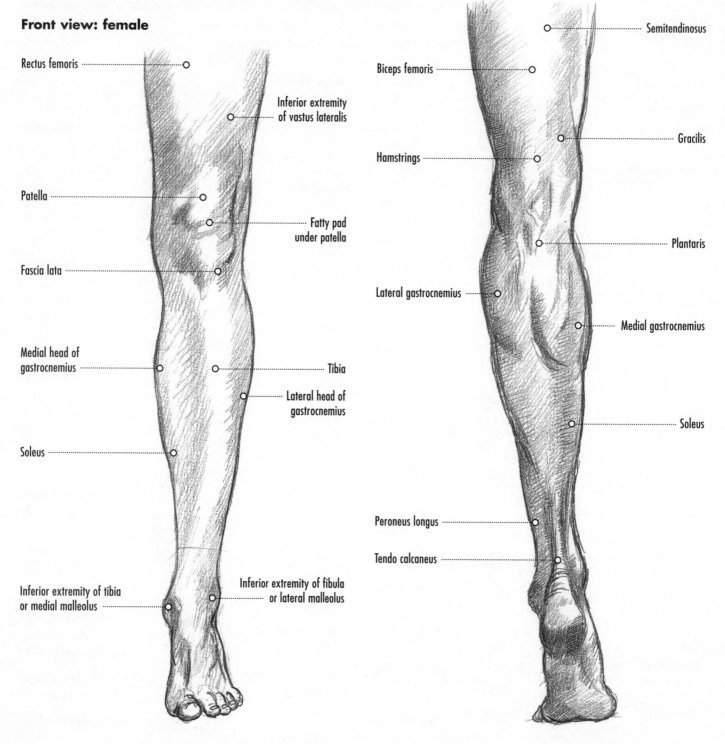

Rectus femoris

Inferior extremity of vastus lateralis

Patella

Fatty pad under patella

Fascia lata

Medial head of gastrocnemius

Tibia

Lateral head of gastrocnemius

Soleus

Inferior extremity of tibia or medial malleolus

Inferior extremity of fibula or lateral malleolus

Biceps femoris

Semitendinosus

Hamstrings

Gracilis

Lateral gastrocnemius

Plantaris

Medial gastrocnemius

Soleus

Peroneus longus

Tendo calcaneus

SKELETON OF THE FOOT

As in the case of the hand, I will deal with the foot separately from the limb, as it is quite a complex feature. It is not such a familiar part of the body either, as people tend to keep their shoes on when walking about in public.

Side view

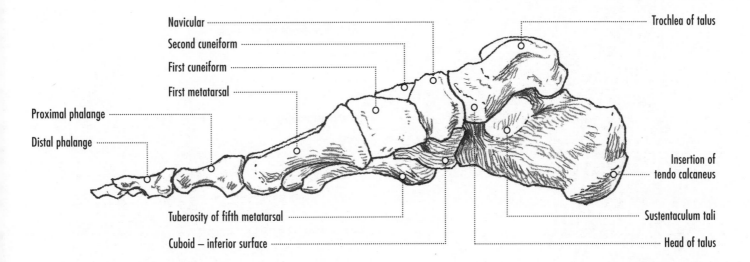

Navicular

Second cuneiform

First cuneiform

First metatarsal

Proximal phalange

Distal phalange

Trochlea of talus

Insertion of tendo calcaneus

Tuberosity of fifth metatarsal

Cuboid – inferior surface

Sustentaculum tali

Head of talus

Top view

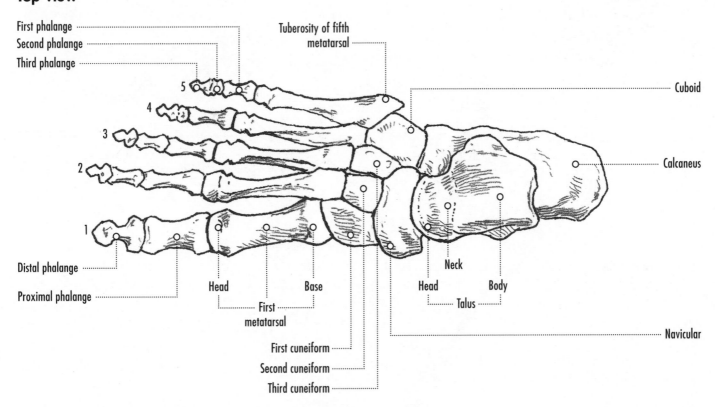

First phalange

Second phalange

Third phalange

Tuberosity of fifth metatarsal

5

4

3

2

1

Cuboid

Calcaneus

Distal phalange

Proximal phalange

Head

Base

First metatarsal

First cuneiform

Second cuneiform

Third cuneiform

Neck

Head

Body

Talus

Navicular

39

MUSCLES AND SURFACE OF THE FOOT

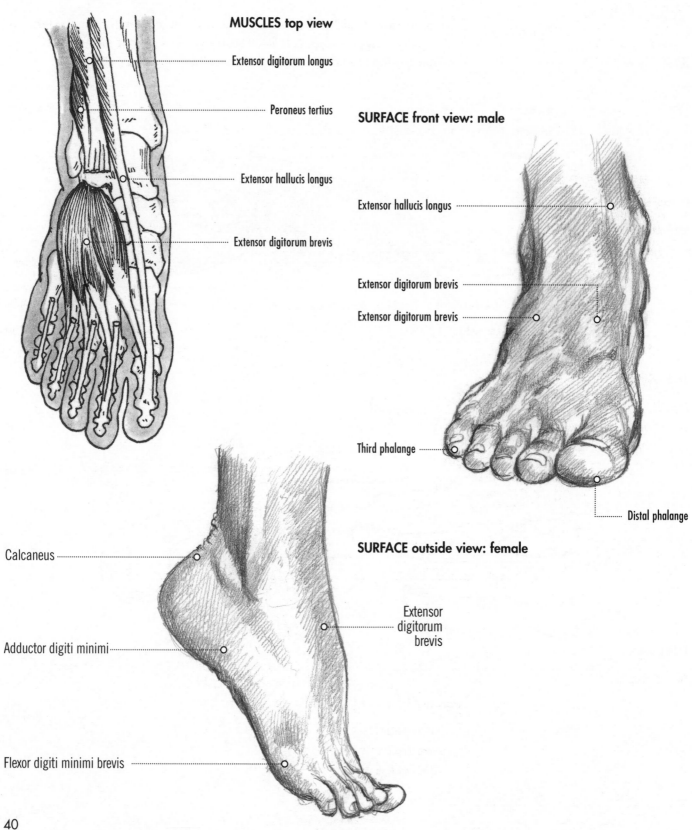

MUSCLES top view

Extensor digitorum longus

Peroneus tertius

Extensor hallucis longus

Extensor digitorum brevis

SURFACE front view: male

Extensor hallucis longus

Extensor digitorum brevis

Extensor digitorum brevis

Third phalange

Distal phalange

SURFACE outside view: female

Calcaneus

Adductor digiti minimi

Flexor digiti minimi brevis

Extensor digitorum brevis

THE LEGS AND FEET: MASTER ARTISTS

After Louis de Boulogne (1654–1733)

After Michelangelo

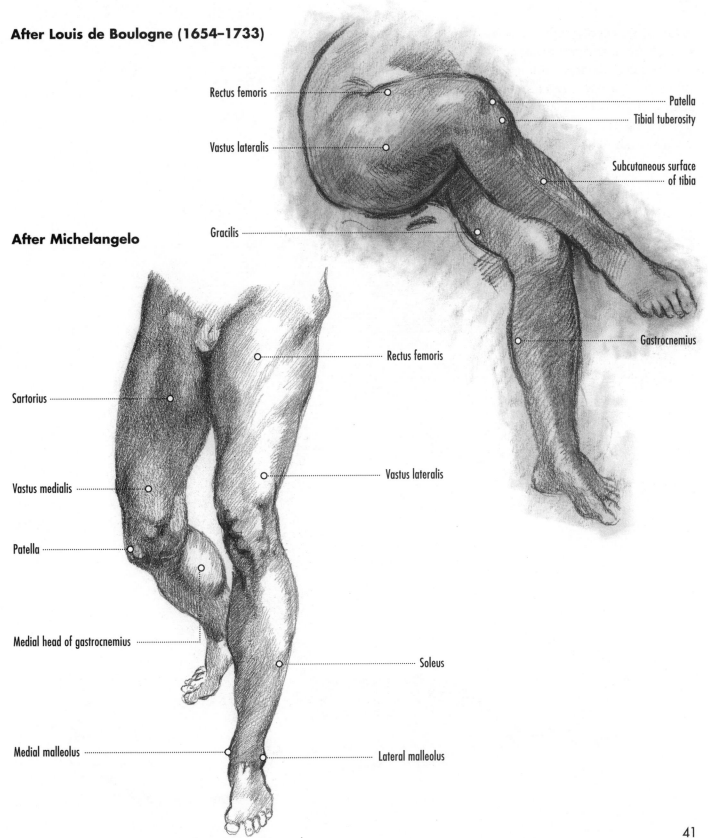

Rectus femoris

Vastus lateralis

Gracilis

Patella

Tibial tuberosity

Subcutaneous surface of tibia

Gastrocnemius

Rectus femoris

Sartorius

Vastus medialis

Patella

Medial head of gastrocnemius

Vastus lateralis

Soleus

Medial malleolus

Lateral malleolus

THE BODY IN MOVEMENT

In this section I present the whole body engaged in action, particularly in sporting activites. These next drawings show models bending and stretching, which, although not a very energetic movement, does bring many of the muscles into play. The girl bending sideways is stretching her thigh muscles as well as all the muscles down one side of her torso.

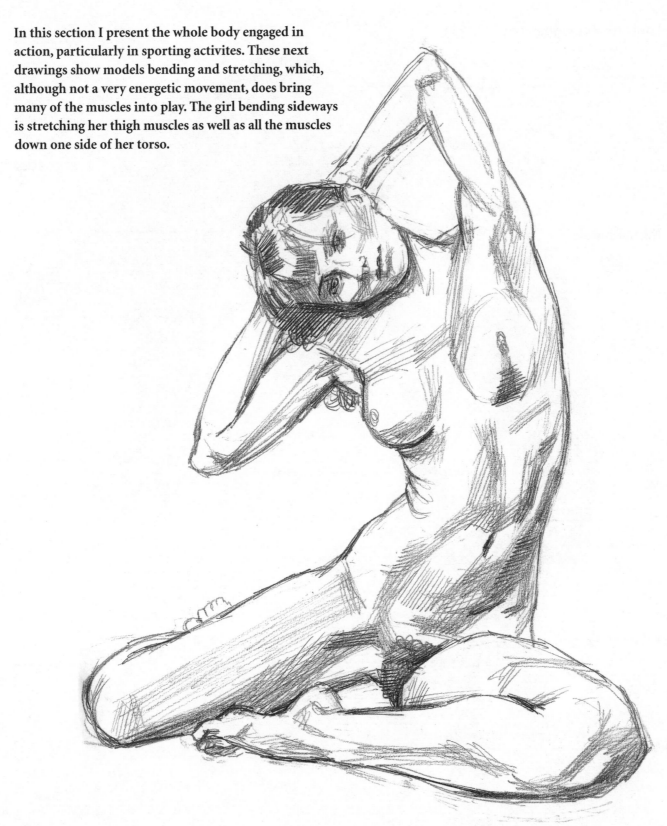

The girl bending over to touch the
floor at her feet is stretching her leg
muscles and those of her back.

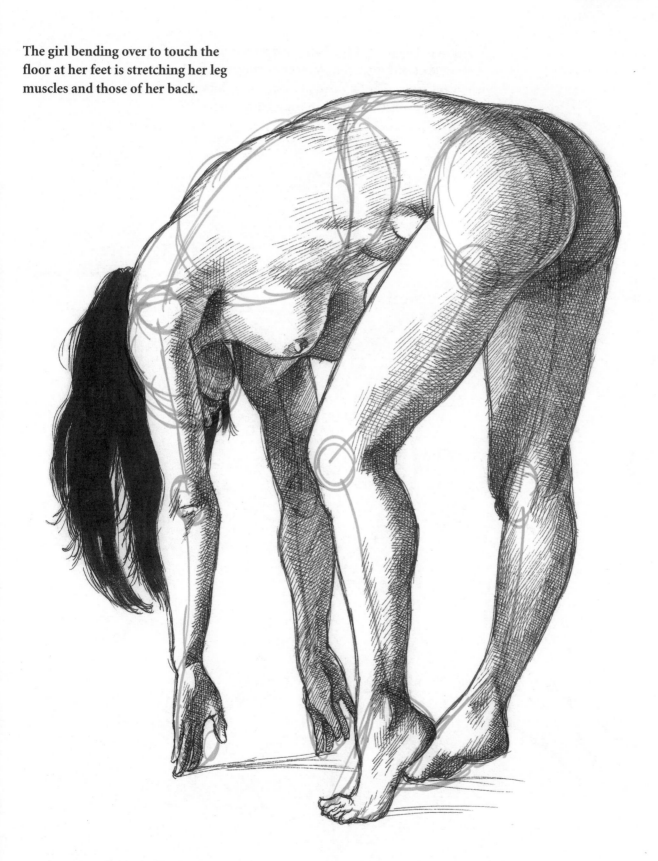

THE BODY IN MOVEMENT

The popular sport of football provides us with many examples of energetic movement, although the players' sporting strip only reveals the muscles in the legs and arms. The first two players, one tackling the other, demonstrate how powerful the action can be in competitive sports.

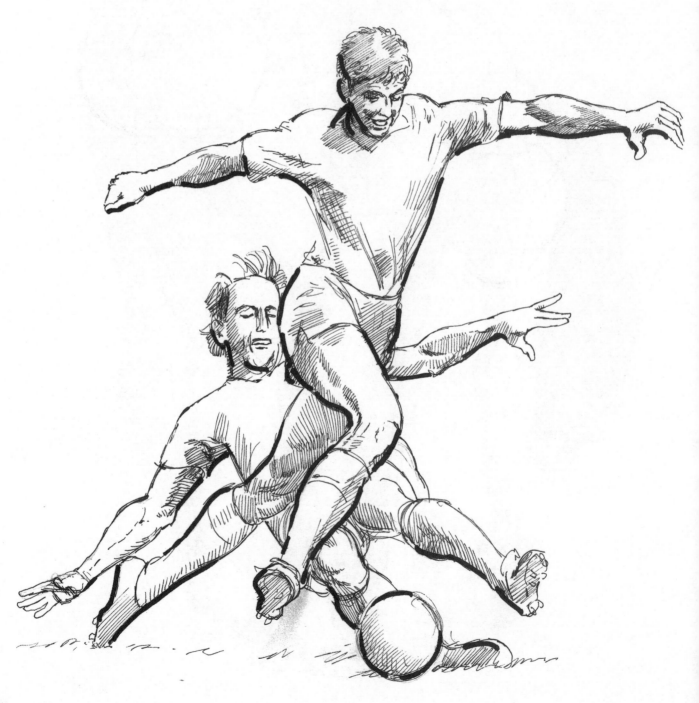

The next three footballers show the movements involved in kicking a ball when in play. The movement of the player at the bottom right is very controlled and deliberate.

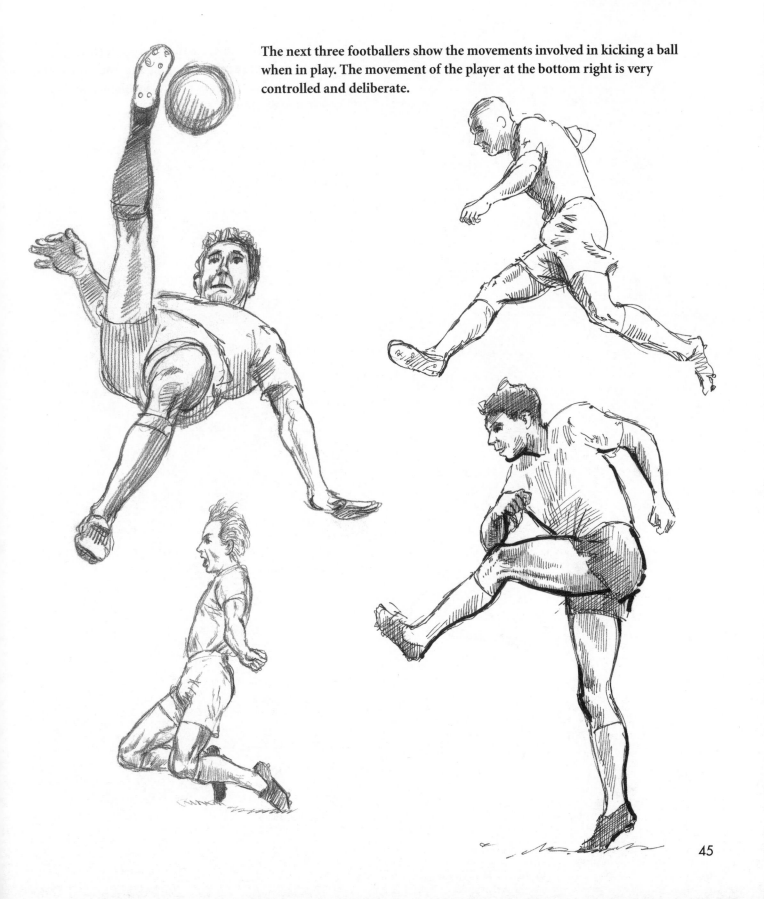

THE BODY IN MOVEMENT

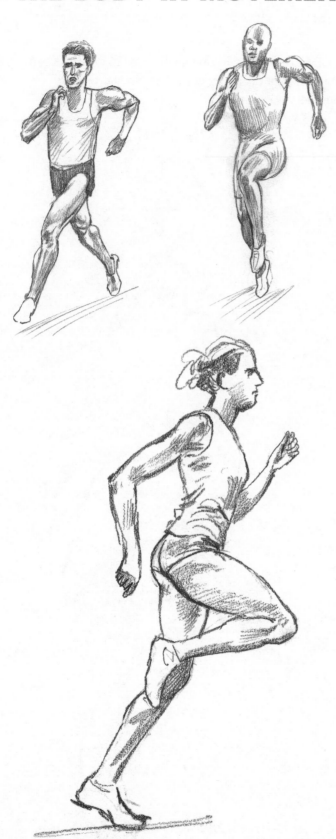

These four runners illustrate the body's efforts to gain speed along a level surface, pumping the arms and legs to keep them moving as fast as possible while remaining balanced and controlled.

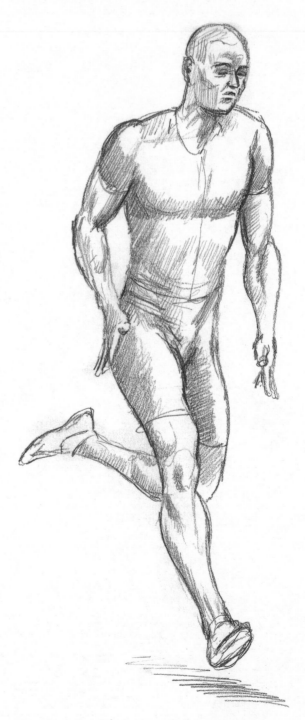

THE BODY IN MOVEMENT: MASTER ARTIST

After Ingres (1780–1867)

The first drawing by Ingres is of a young man bending dramatically down to gather something up, while looking backwards.

The second drawing is of a nymph stretching upwards, showing the tension in her body as she does so. Ingres doesn't define the muscles very sharply, preferring a smoother overall look to his figures. Nevertheless, it is obvious enough which muscles are being indicated in these drawings.

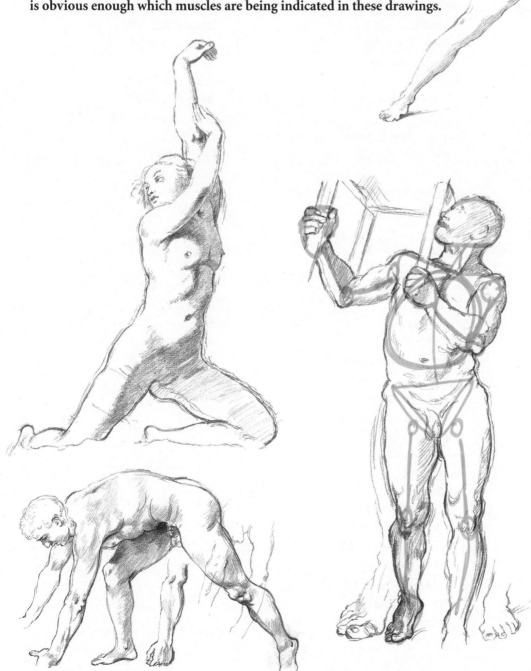

The next drawing shows a man lifting a chair above his shoulder as he walks forward. The arm muscles are particularly obvious.

The final Ingres life study shows a man reaching down to lift something from the ground. The stretching of the legs and arms brings into play all the muscles of the limbs.

As happens in many life drawings done by accomplished artists, Ingres has drawn extra definitions of the feet in the standing pose and the stretched arm in the drawing on the left. These workings help to clarify what is actually happening in a complex part of the pose.

INDEX